Beautiful Skulls

A coloring book for adults!

By: Heaven Forney

Color Testing Page

For best results use color pencil

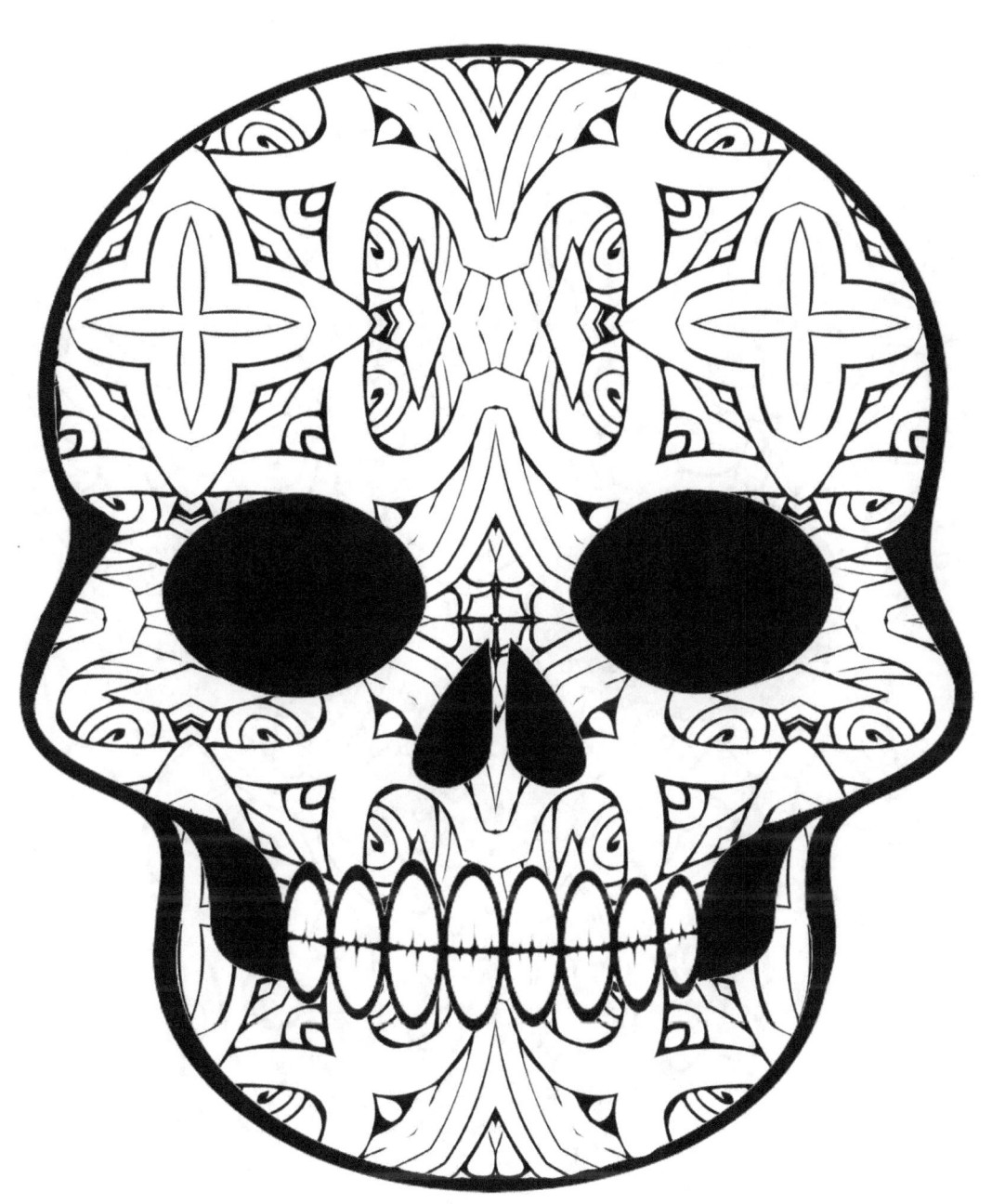

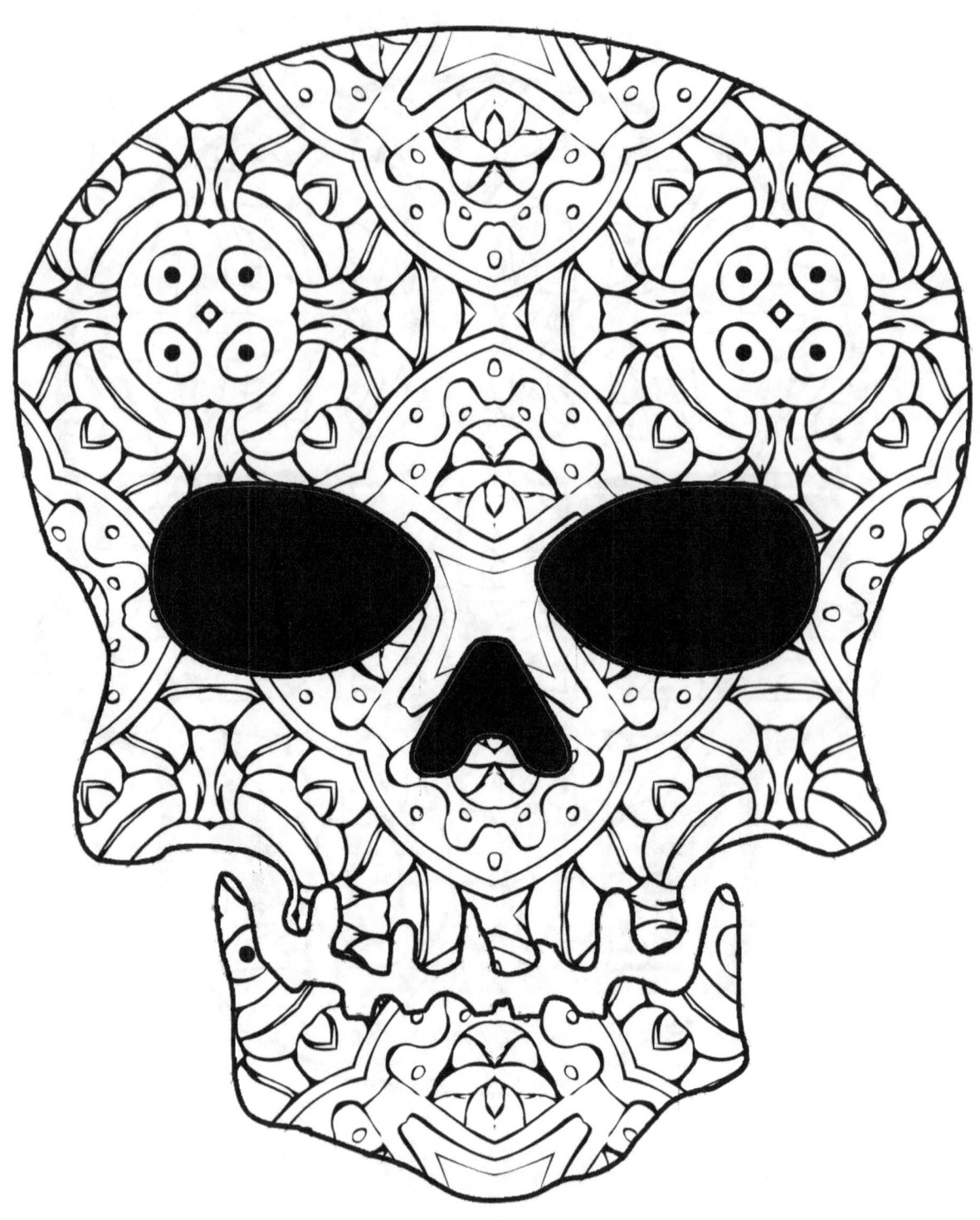

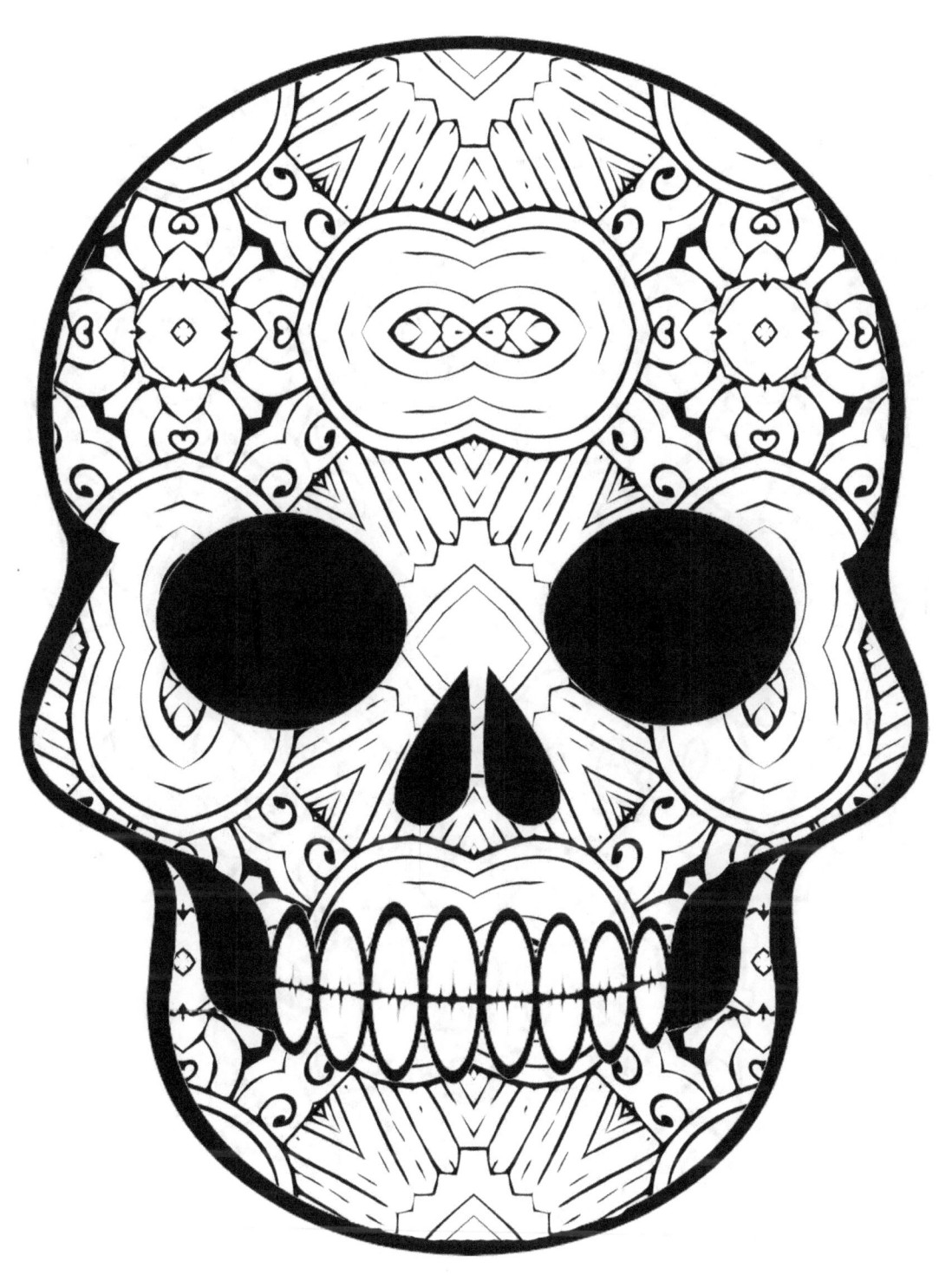

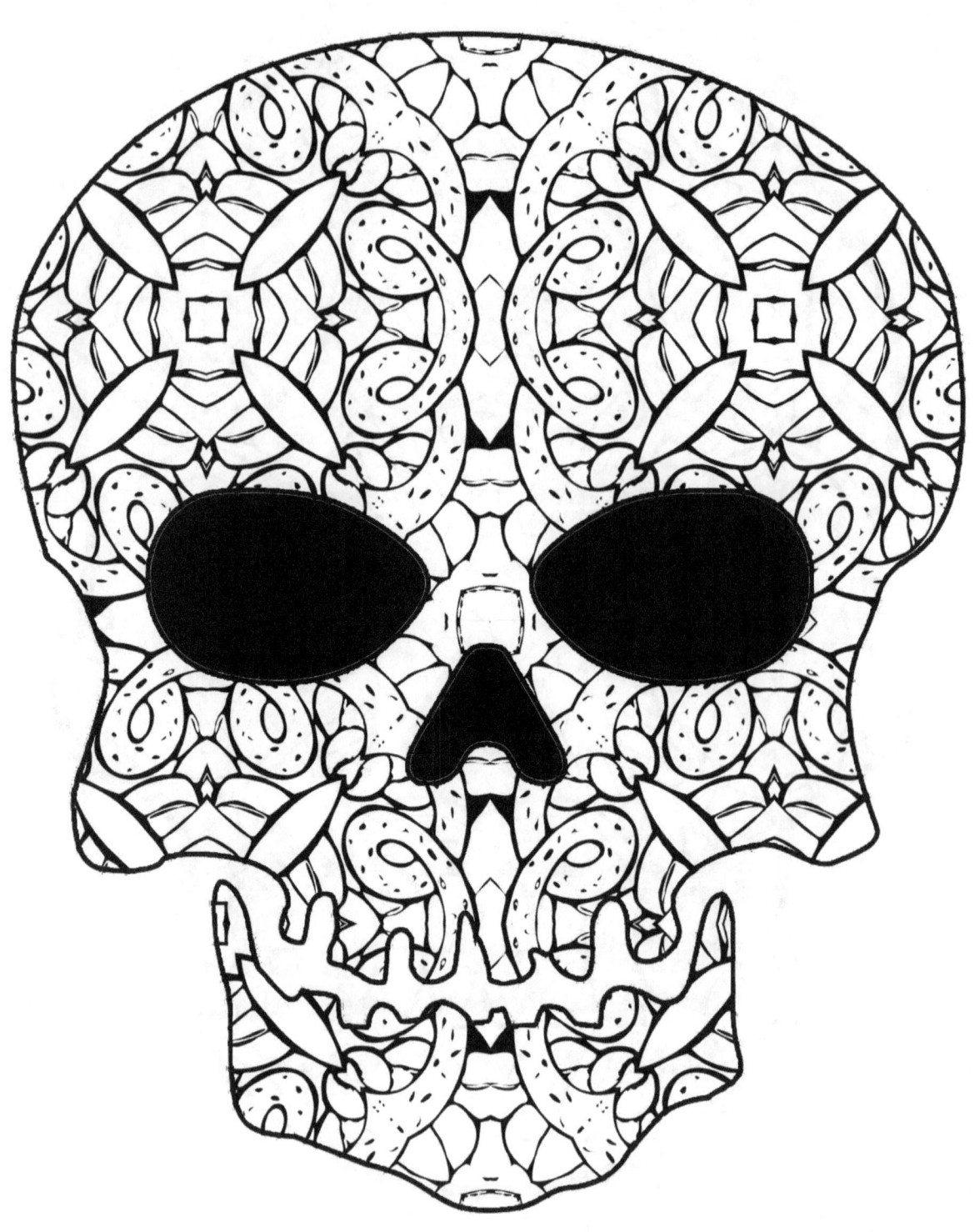

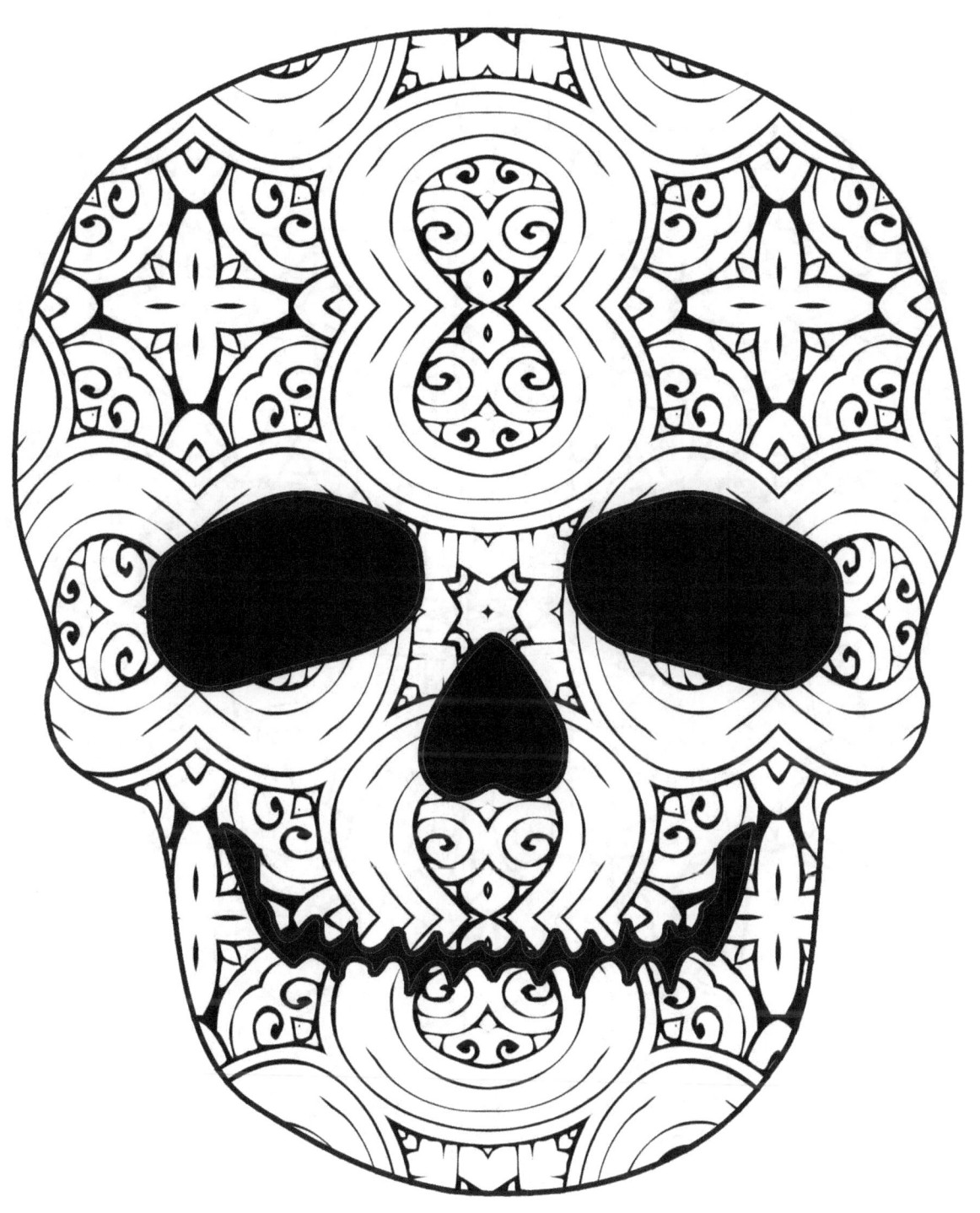

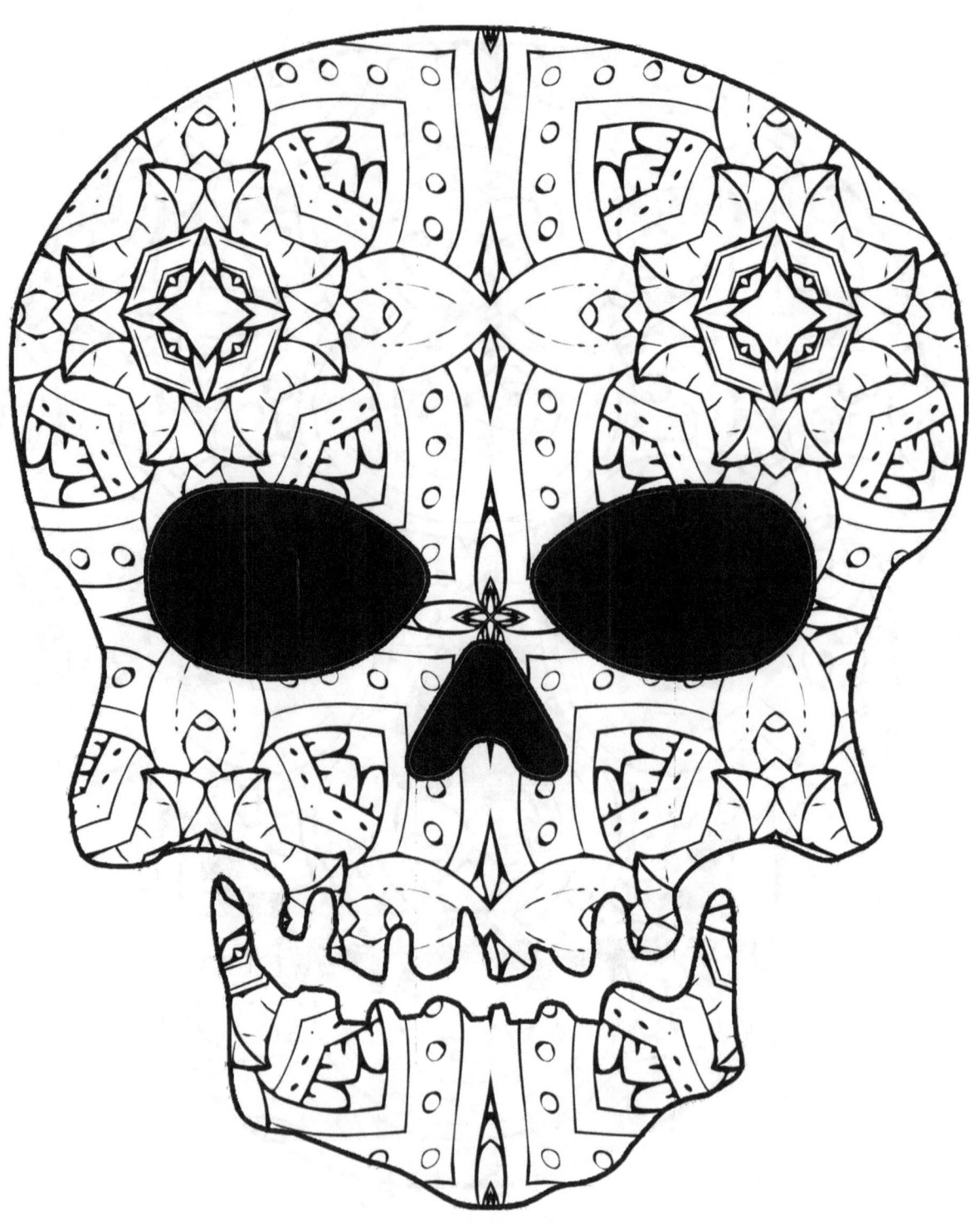

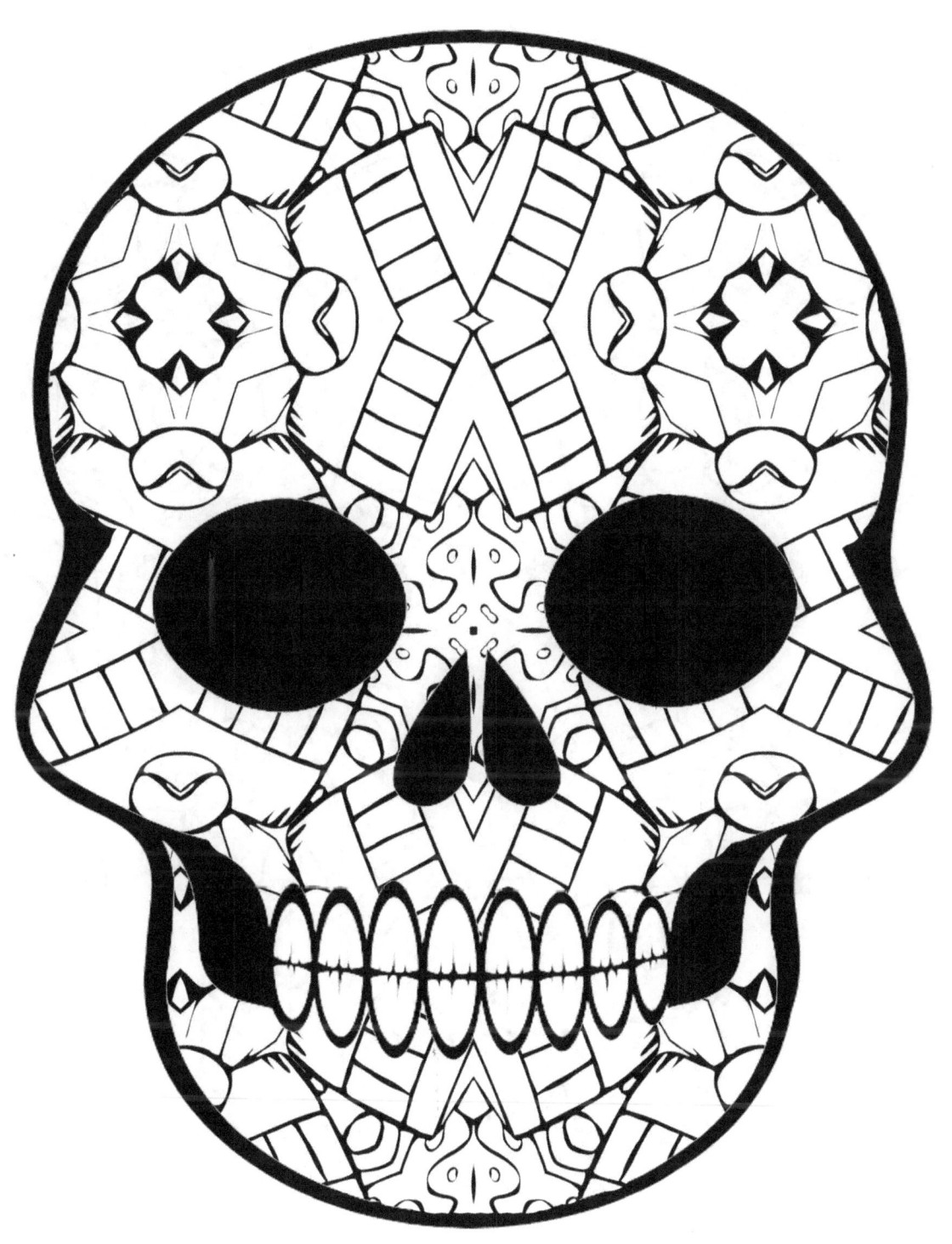

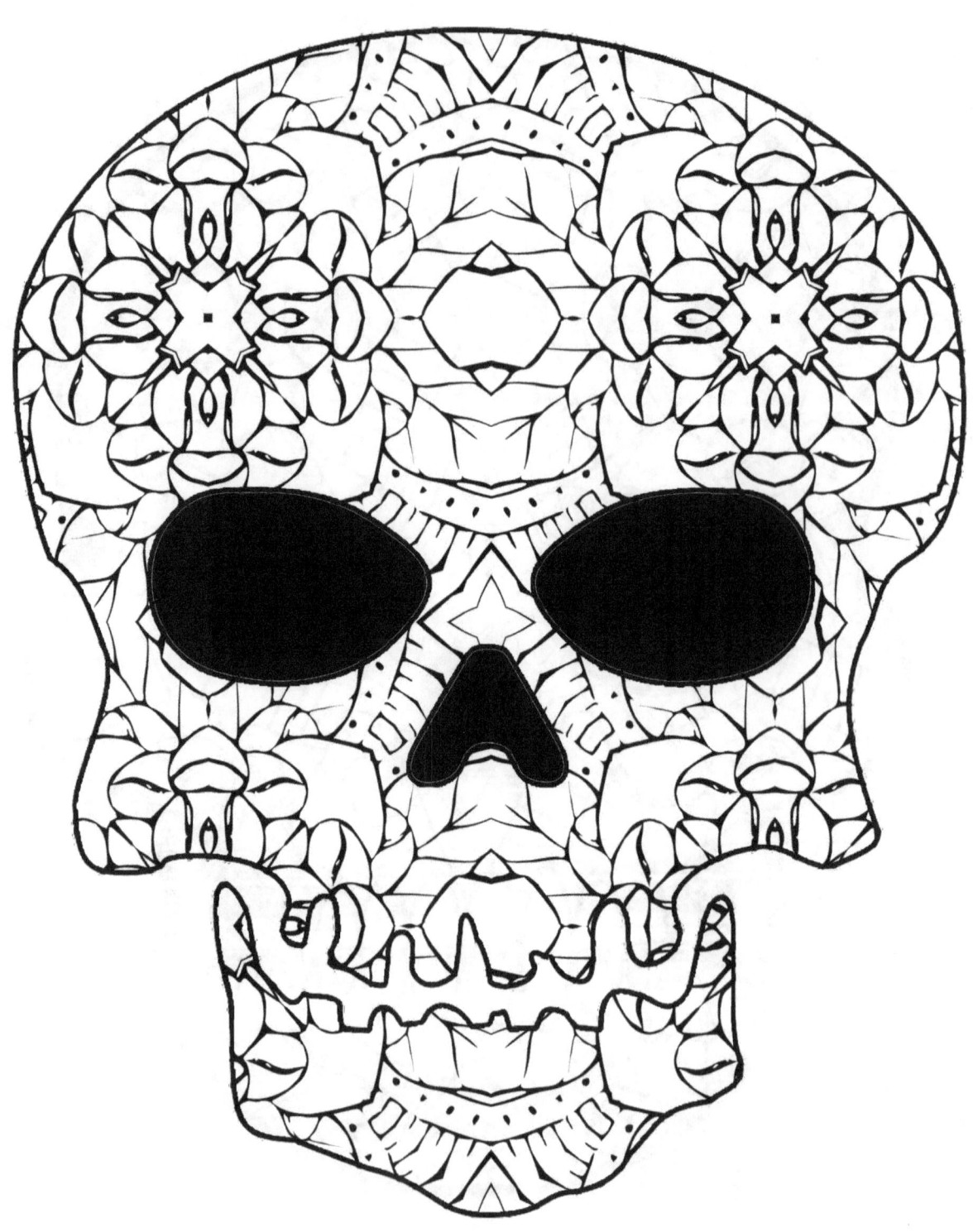

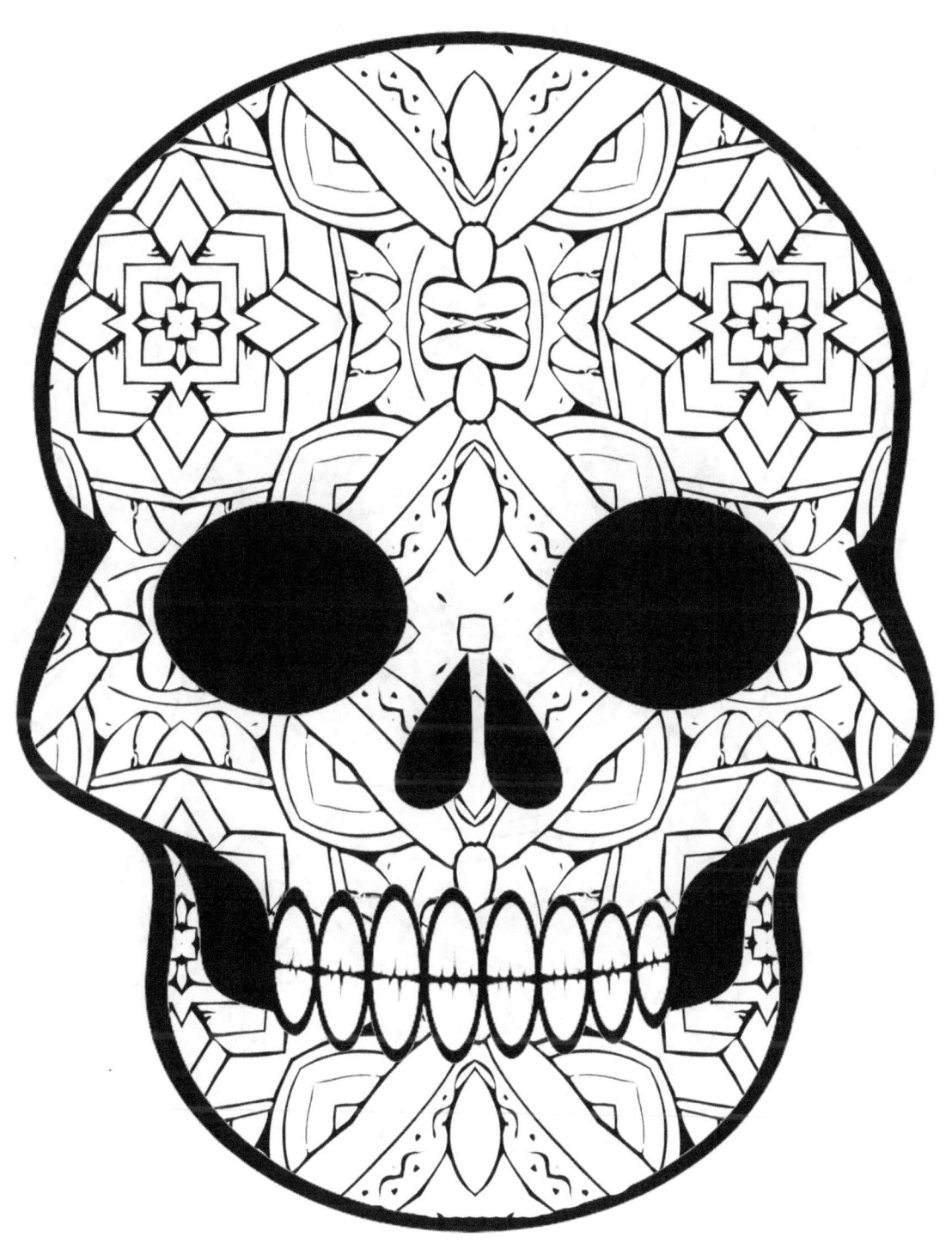

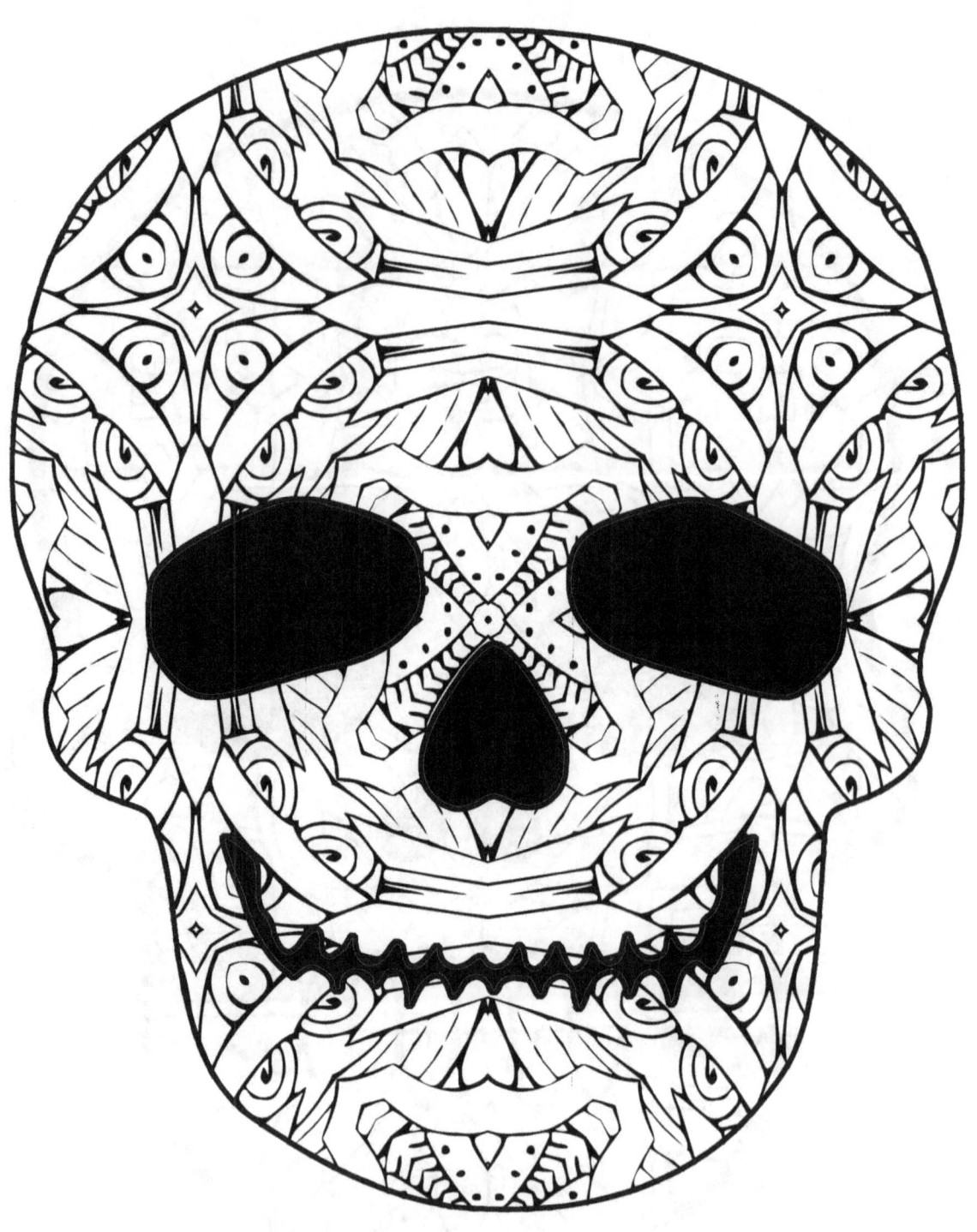

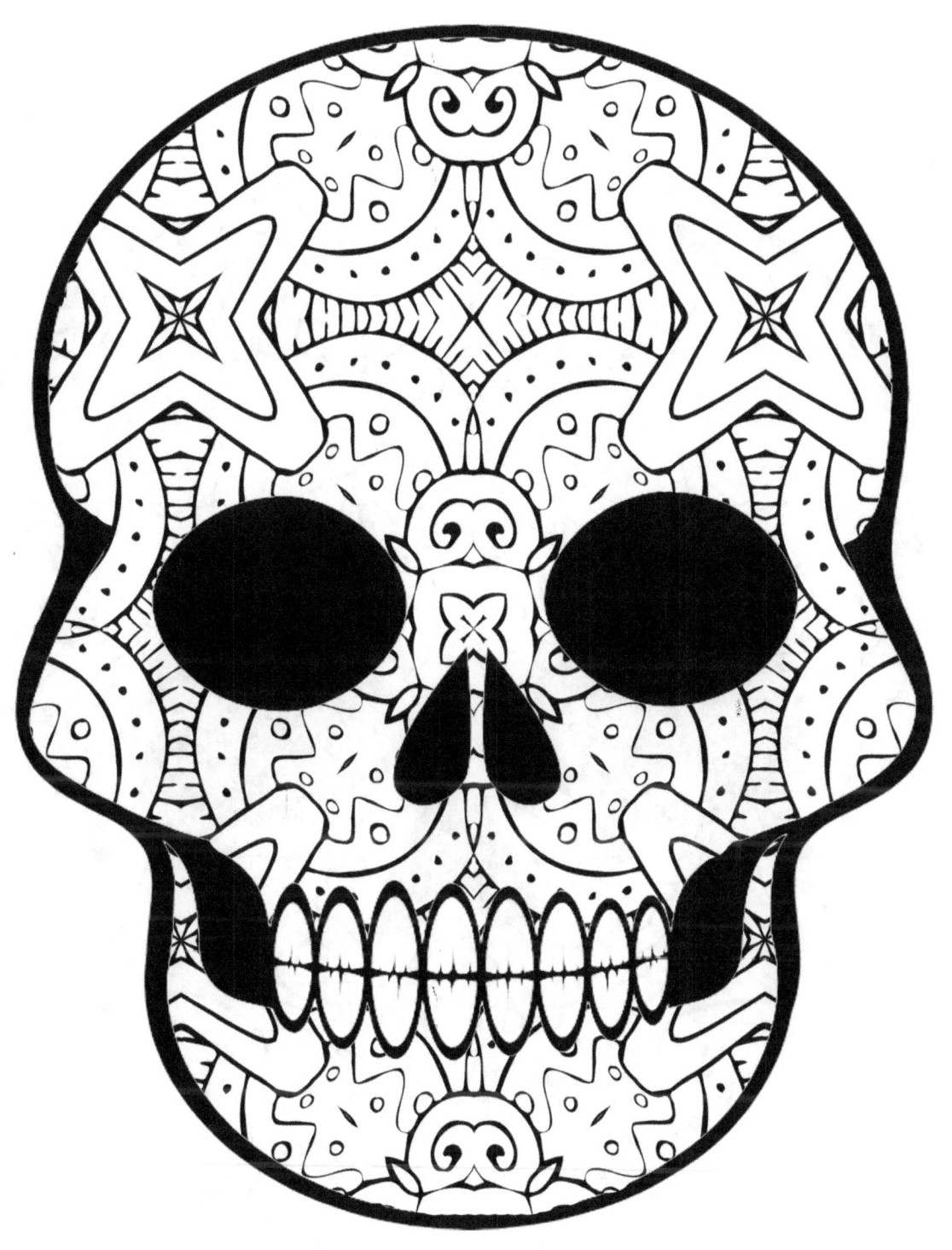

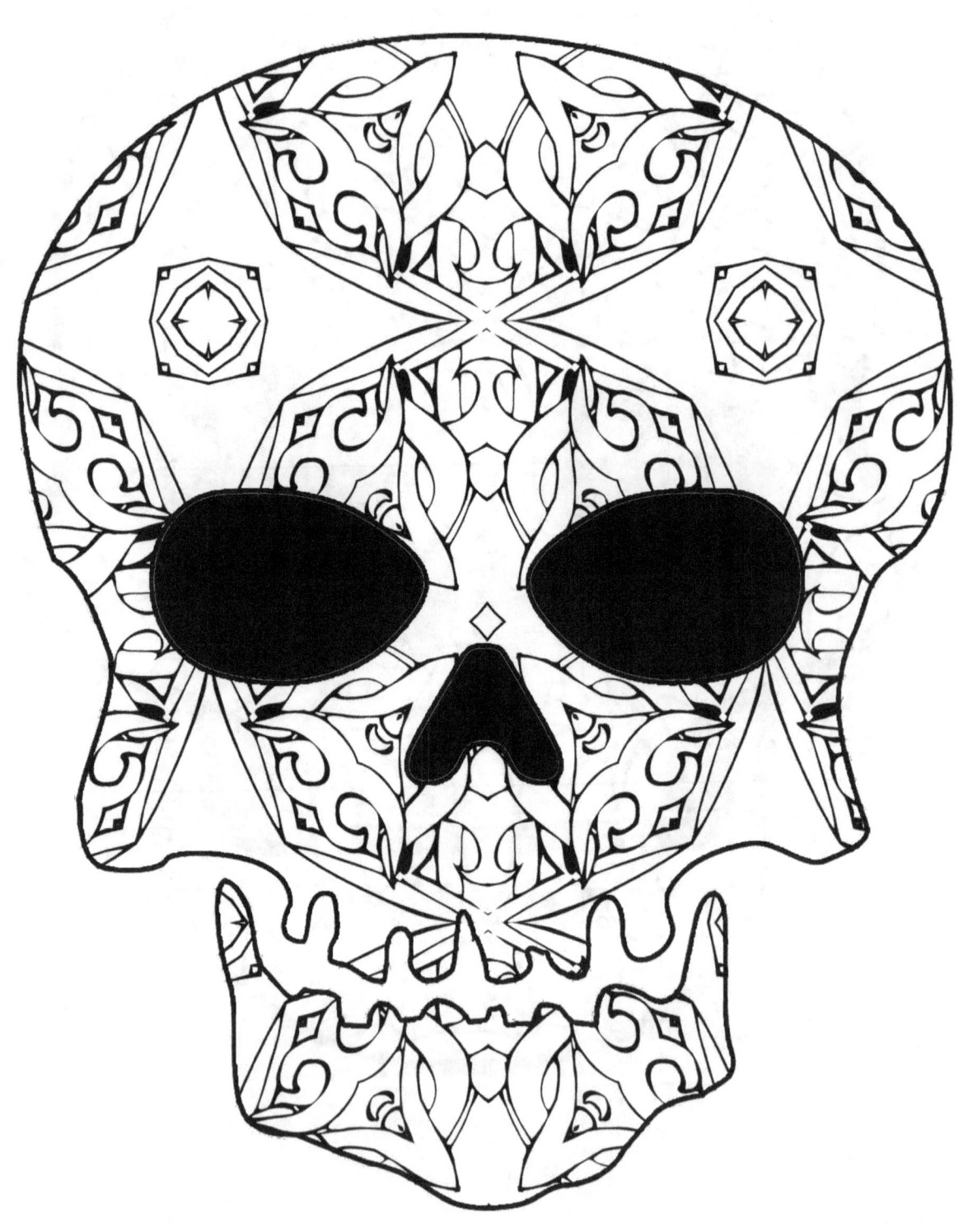

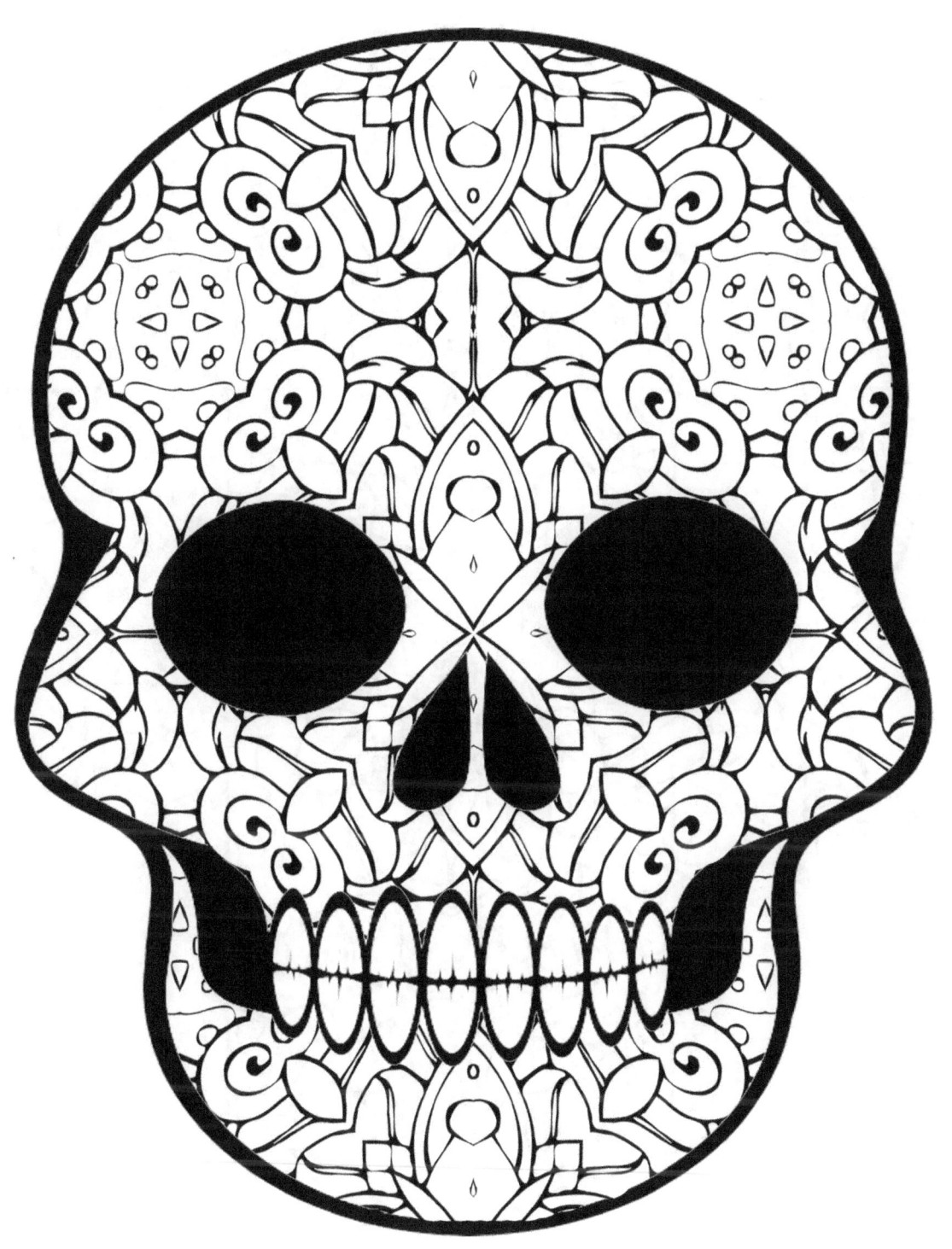

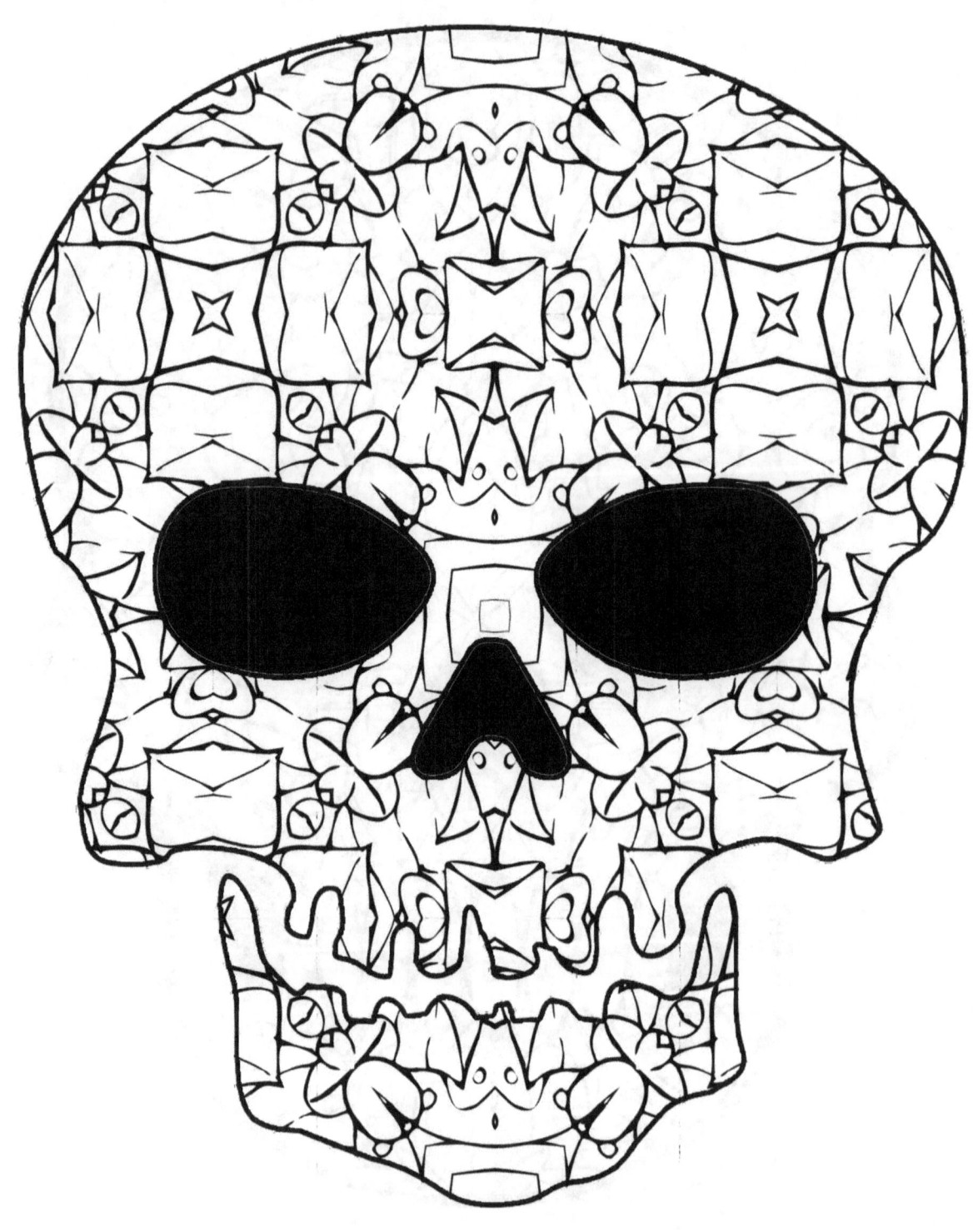

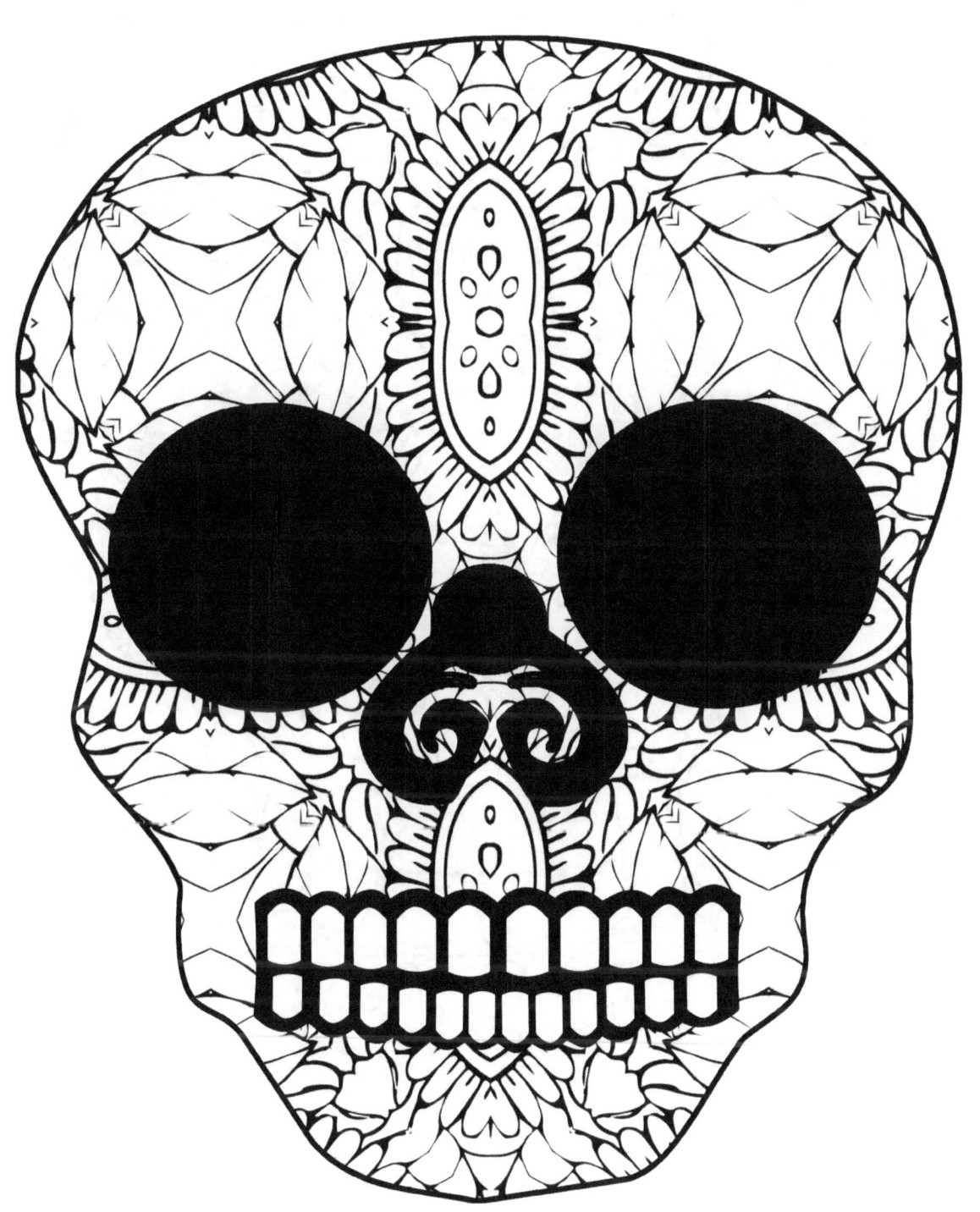

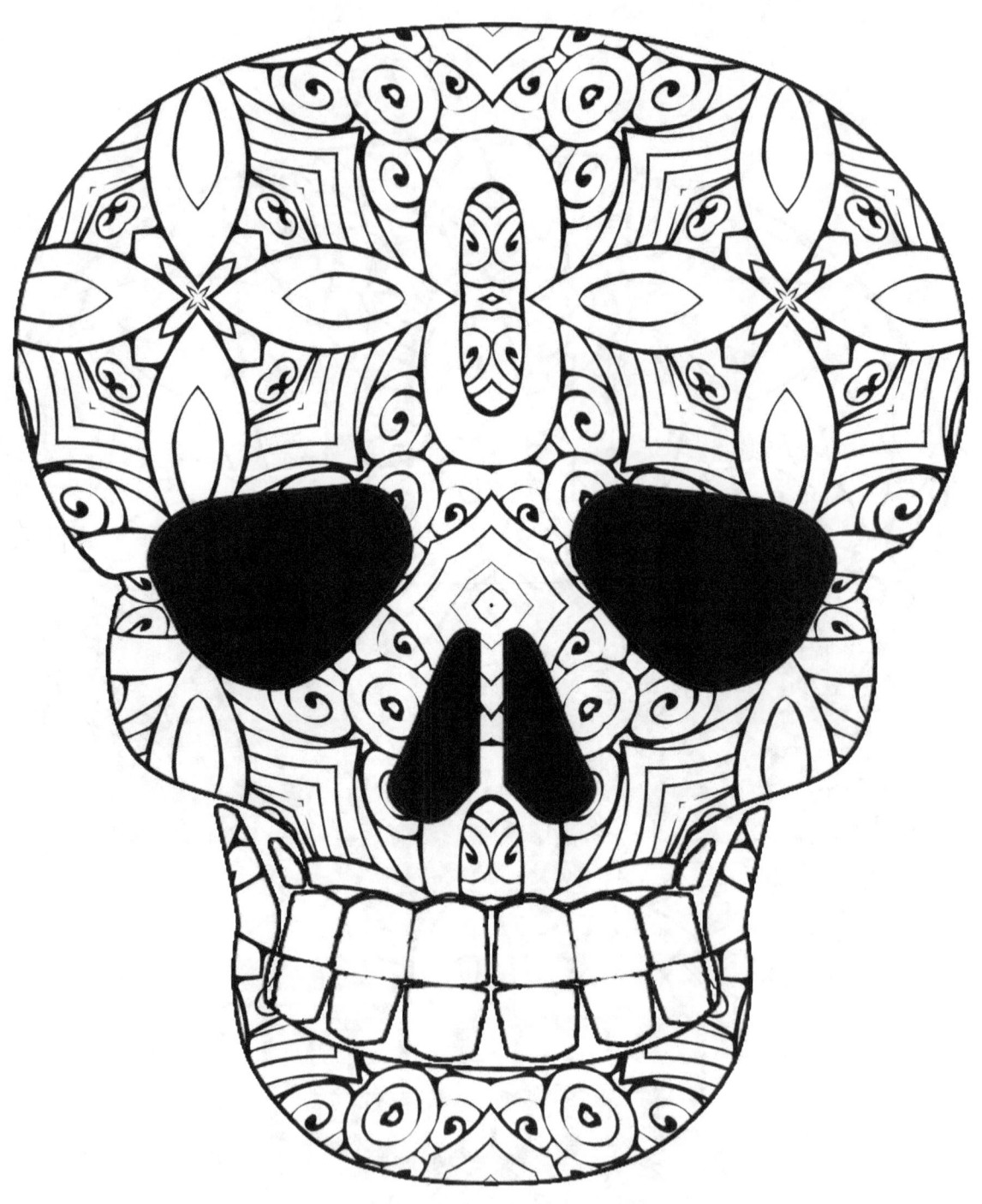

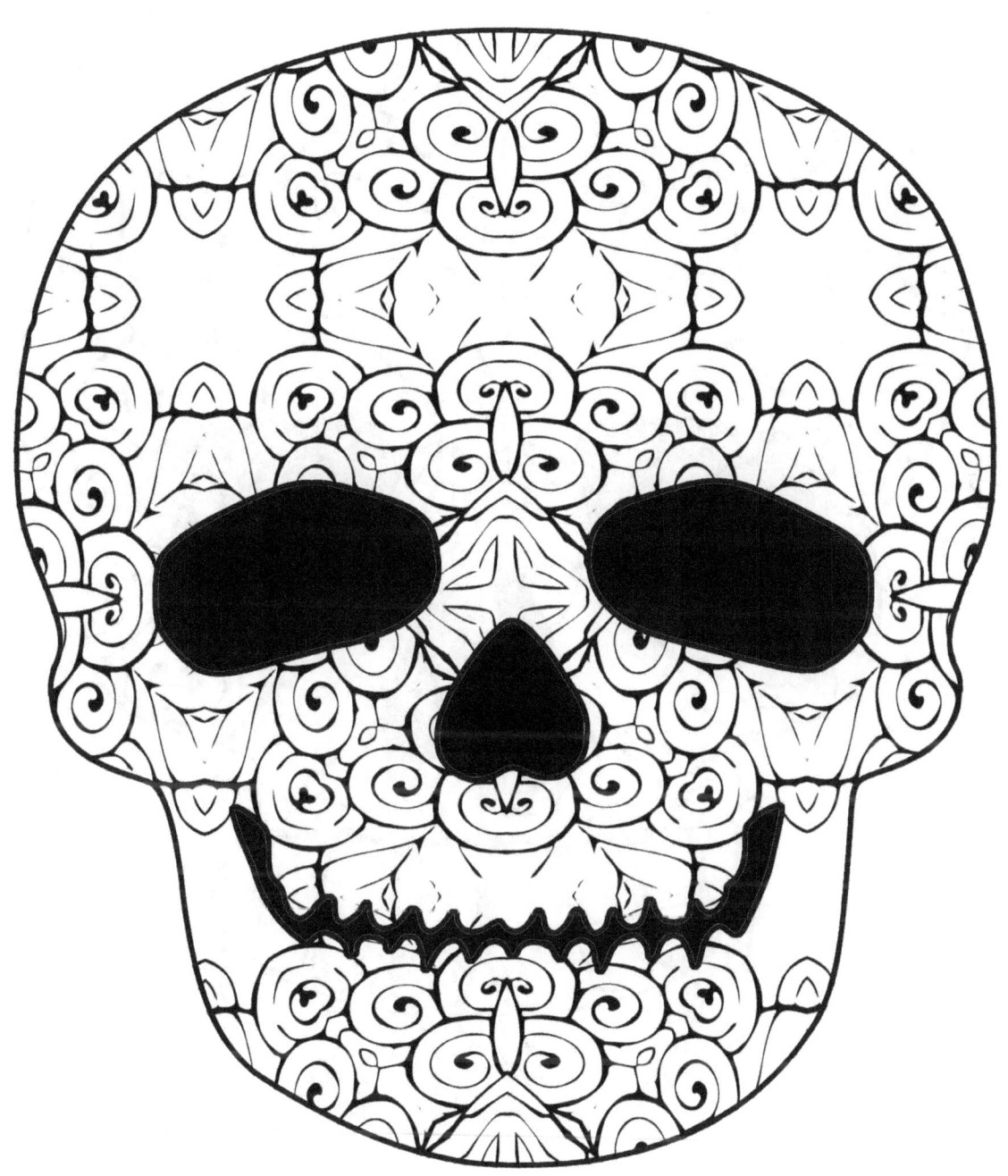

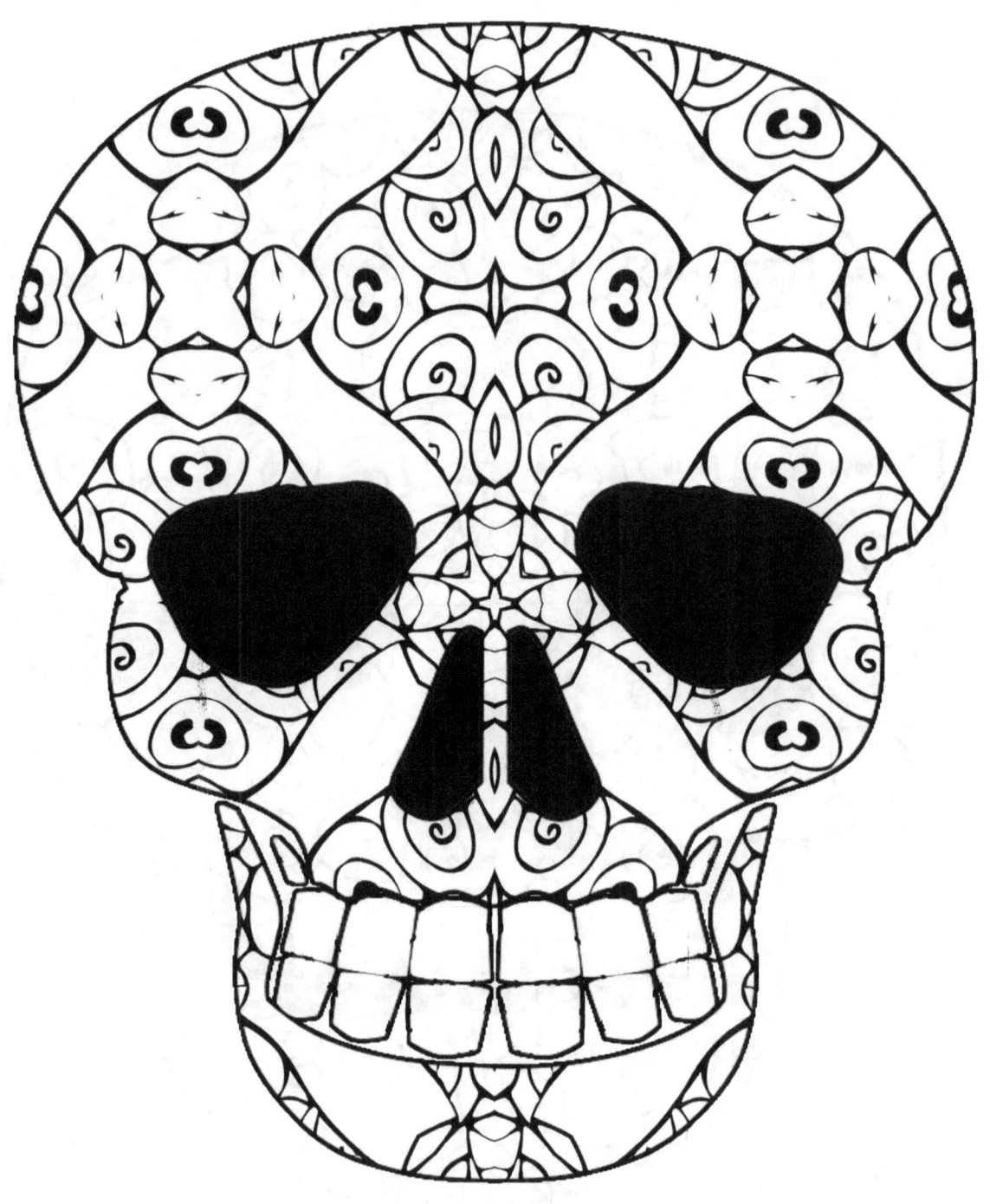

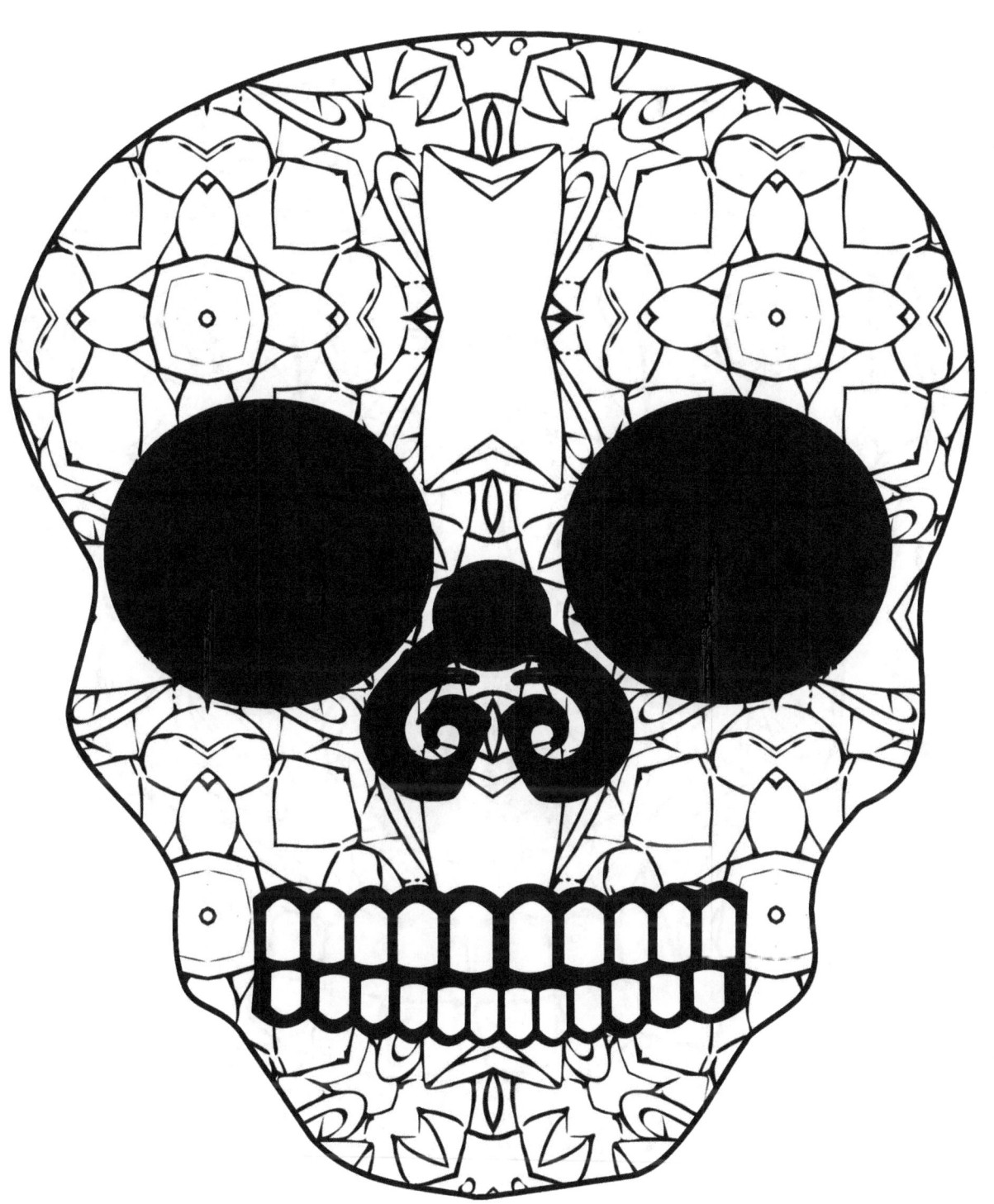

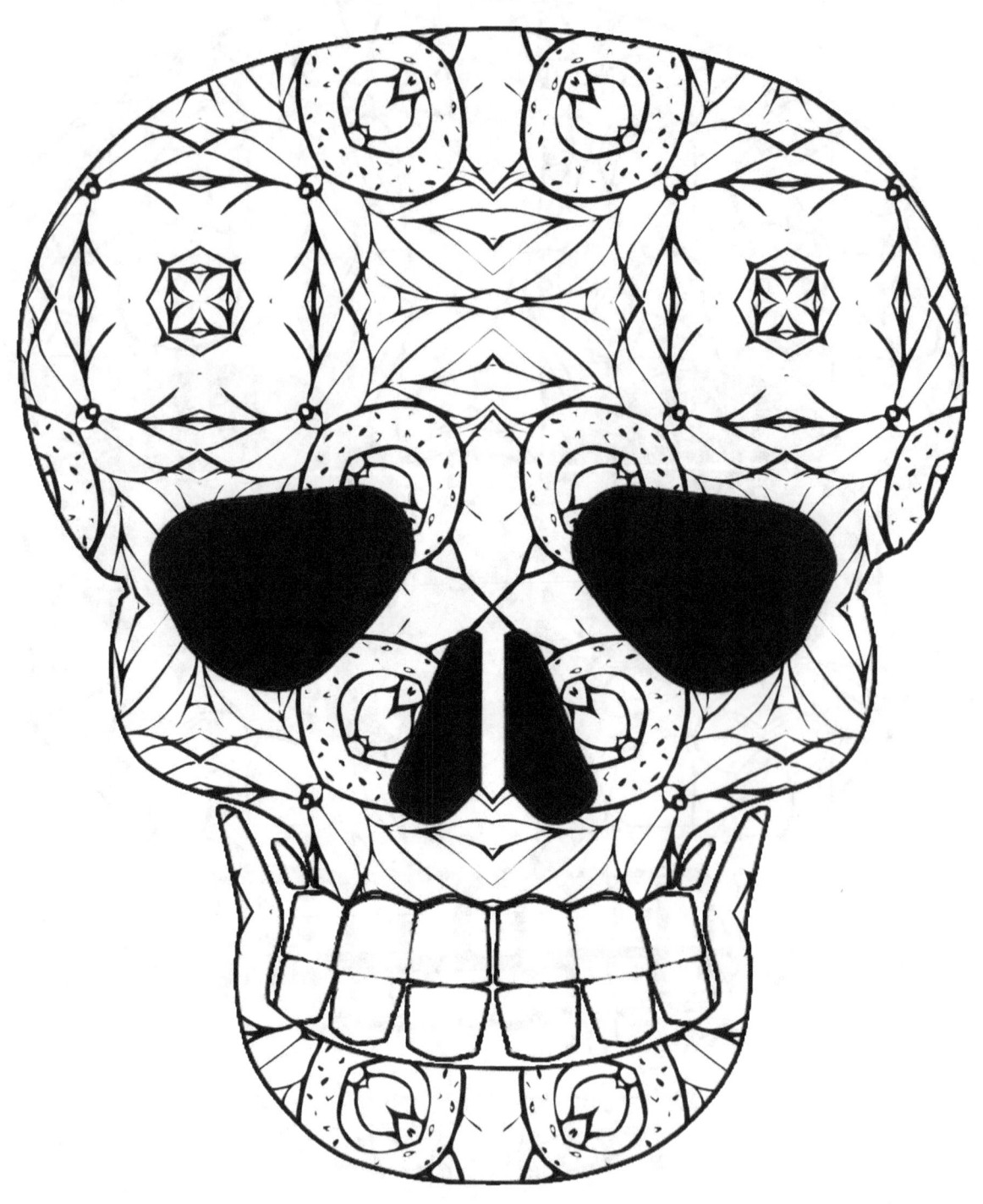

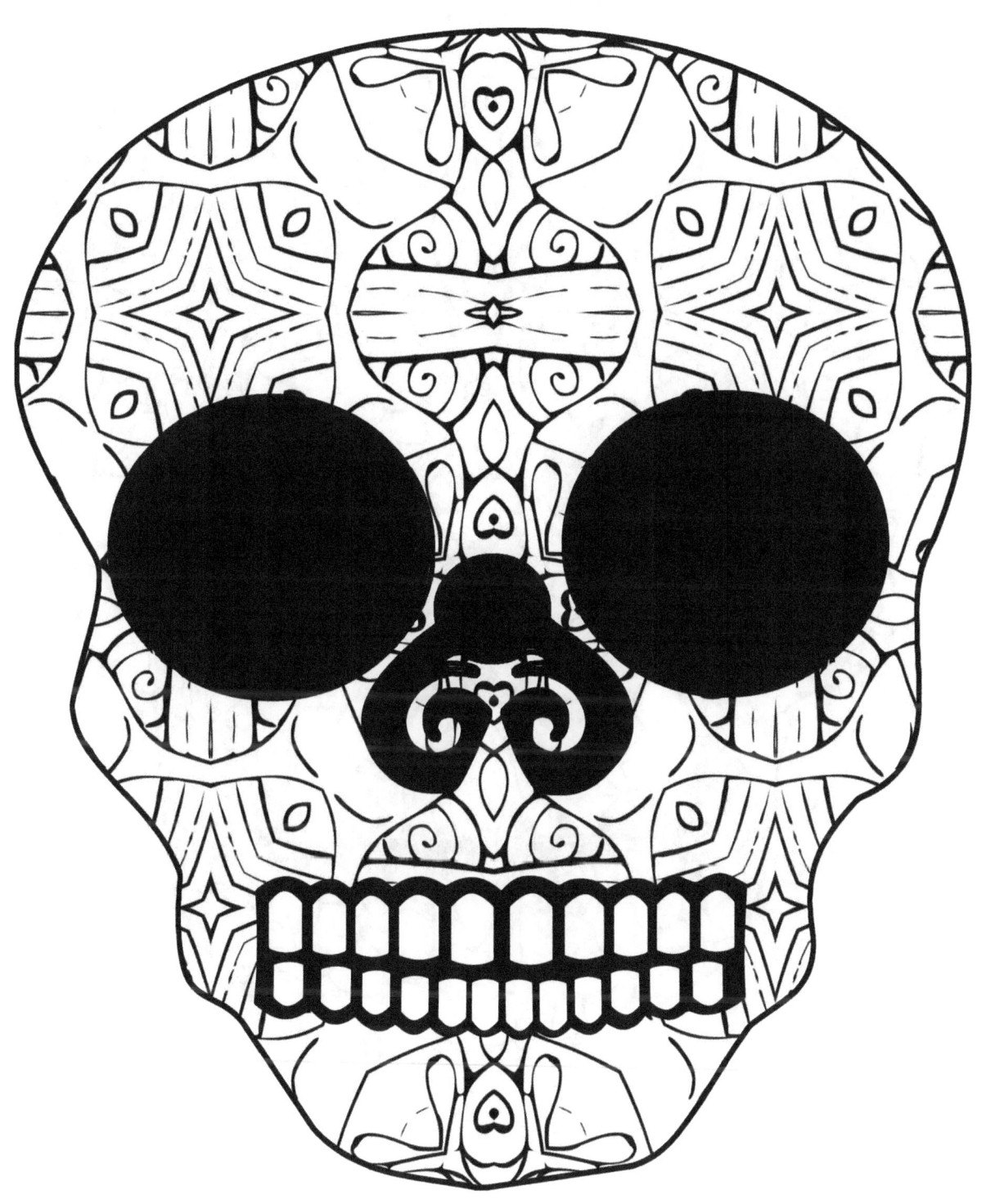

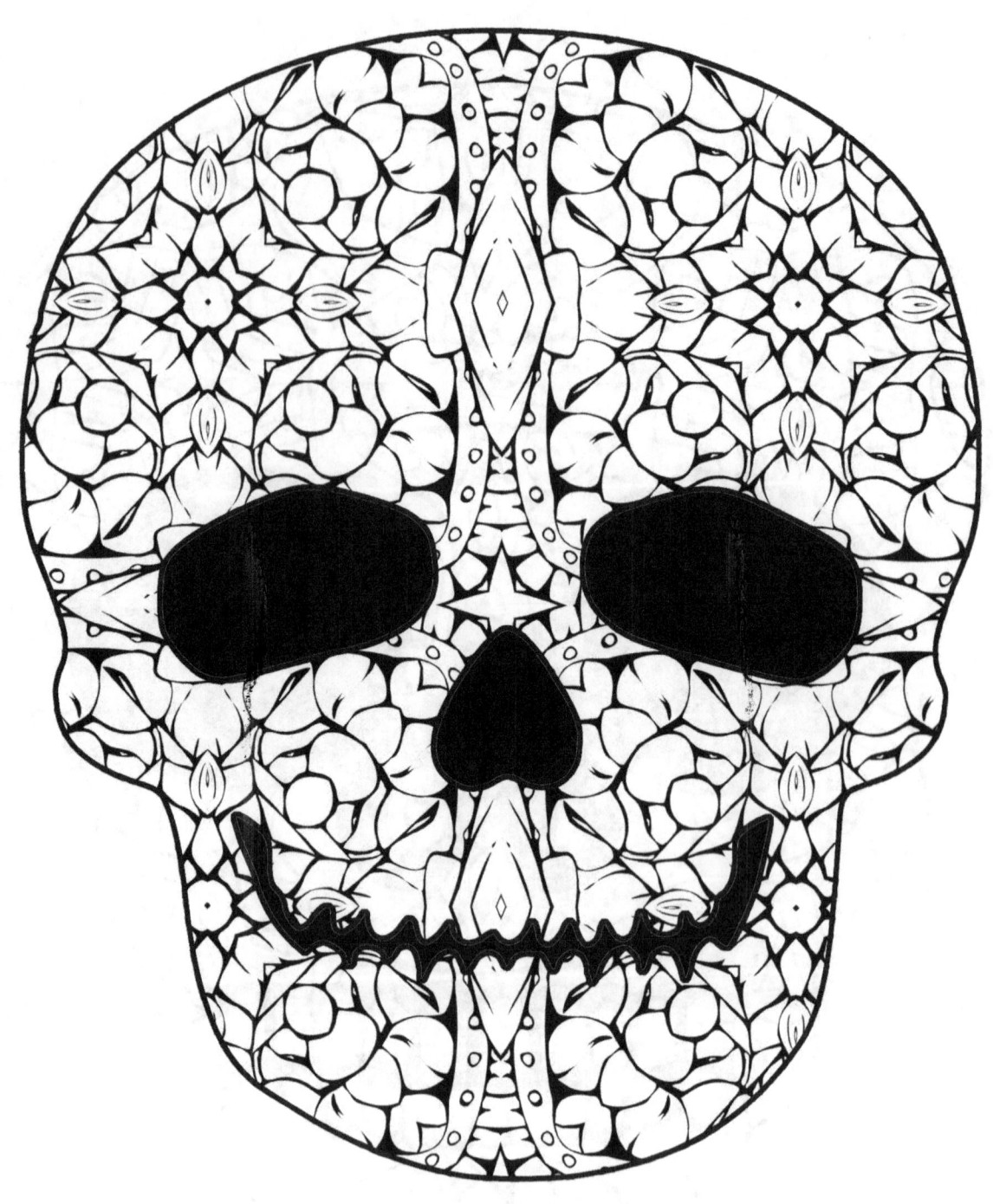

Stay Relaxed